BLACKWORK

Lesley Barnett

D0101875

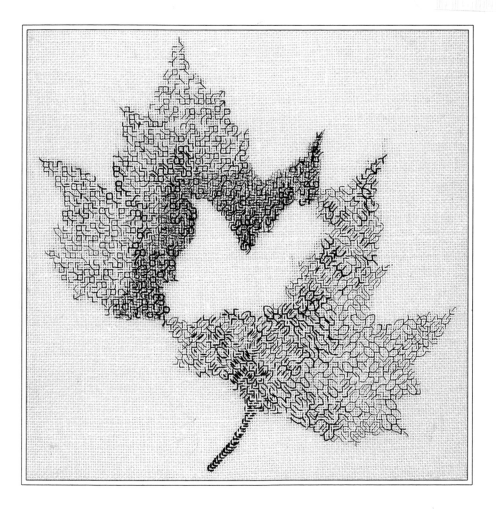

Search Press

First published in Great Britain 1996

Search Press Limited
Wellwood, North Farm Road,
Tunbridge Wells, Kent TN2 3DR

Copyright © Search Press Ltd. 1996

Photographs copyright © Search Press Ltd. 1996
All photographs by Search Press Studios except for those on pages 4
and 5, which are by Julia Hedgecoe and are reproduced by kind
permission of the Embroiderers' Guild, and those of Margaret
Pascoe's work on pages 1, 9, 14, 25 and 41, which are by Jim Pascoe.

The text of this book is based on that of *Blackwork* by Margaret
Pascoe, previously published by Search Press, with revisions and
additions by Lesley Barnett.

All rights reserved. No part of this book, text, photographs or
illustrations, may be reproduced or transmitted in any form or by
any means by print, photoprint, microfilm, microfiche, photocopier,
or in any way known or as yet unknown, or stored in a retrieval
system, without written permission obtained beforehand from
Search Press.

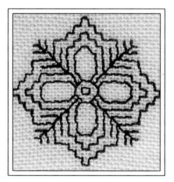

ISBN 0 85532 806 1

Printed in Spain by A.G. Elkar S. Coop, 48012 Bilbao

Contents

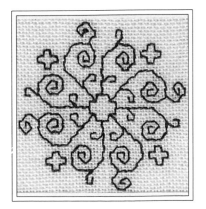

Introduction and history

Blackwork is embroidery done with straight stitches in a contrasting colour on linen or similar fabric, usually black threads on a white ground. The fabric threads should be clear enough to be counted easily, and there must be the same number of threads per centimetre or inch in both the warp and the weft. By counting threads of the material in varying numbers, a great variety of geometric patterns can be built up with simple running stitches.

In the early sixteenth century, repeating patterns in blackwork were used to decorate clothing, often on collars and cuffs. The patterns were stitched using double running stitch so that the design was identical on both sides of the fabric. Examples can be seen depicted in portraits by Hans Holbein and other artists, and double running stitch is sometimes called Holbein stitch as a result.

The style of blackwork embroidery changed, and in the time of Elizabeth I the patterns were used to fill areas in scrolling and floral designs for both clothing and household furnishings. These fillings produced a lace-like network sometimes known as diaper patterns, which were often outlined in braided or chain stitches in a silver-gilt thread. Tiny individual straight stitches were also used as seeding or speckling to give a shaded effect similar to that seen in the book illustrations of the time.

The fineness and intricacy of the Elizabethan blackwork embroidery is the inspiration for much modern blackwork, though few today aspire to the same minute detail seen in the examples shown from the Embroiderers' Guild collection.

There is very little evidence of blackwork stitching during the period 1700 to 1900, but it has become popular again in the twentieth century. In the 1920s and 1930s, many household articles were embroidered with designs in which blackwork patterns filled areas and made borders.

Blackwork designs today, in common with many other art forms, are less formal. During the 1950s and 1960s, embroidery became 'creative' and blackwork has become rather freer in style. The emphasis on decorating household articles has been lost, but the same little patterns are used to make pictures, both figurative and abstract. These, like black and white photographs or drawings, rely on contrasting light and dark for their effect. Areas which have no hard outlines and show a great variety of tones, from pure black to white, are the essence of this new use for traditional blackwork patterns.

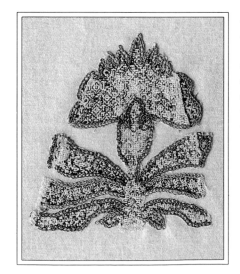

A blackwork motif of the late sixteenth century from the Embroiderers' Guild collection (EG 206). Linen embroidered with black silk and silver-gilt threads. Original size: 7.5 x 7.5cm (3 x 3in).

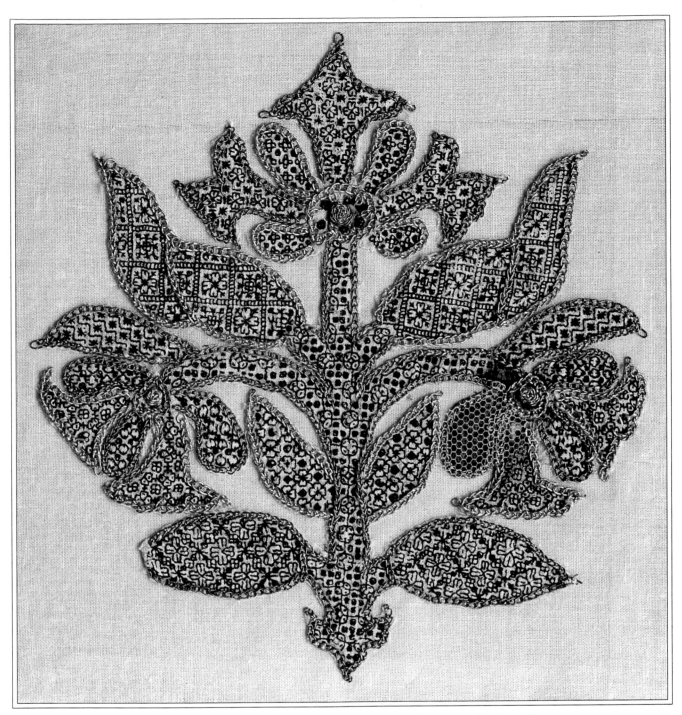

A stylised honeysuckle motif from the last decade of the sixteenth century from the Embroiderers'
Guild collection (EG 207). This may have formed part of the embroidery on a long pillow cover.
Linen embroidered with black silk and silver-gilt threads.
Original size: 7.5 x 7.5cm (3 x 3in). Enlarged to show the quality of the work.

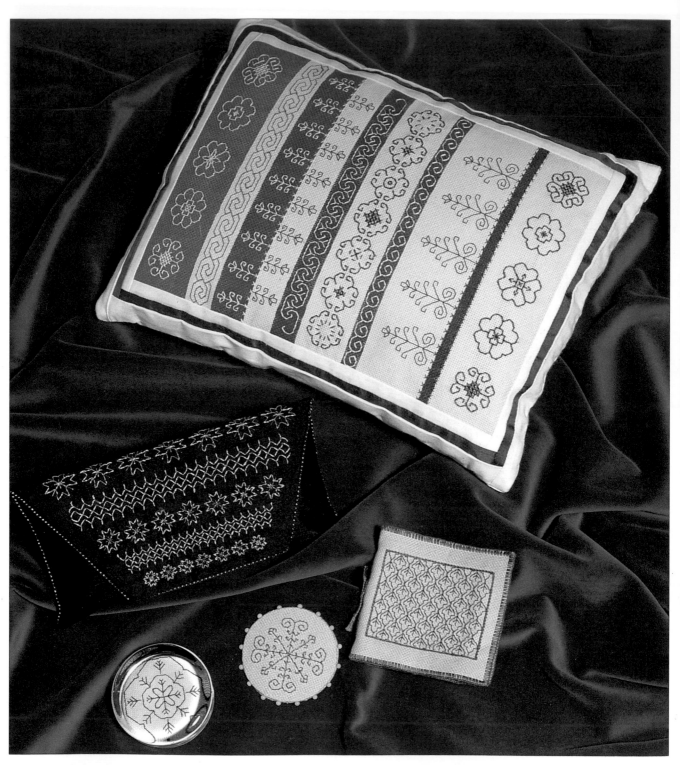

Green and Cream Cushion, *by Lesley Barnett. Original size: 24 x 30cm (9¹/₂ x 12in). Cream Aida fabric sponged with fabric paint over masking tape to create stripes of colour. The embroidery shows how straight stitch patterns can give the impression of curves.* **Black and Gold Evening Bag,** *by Lesley Barnett. Original size: 10 x 20cm (4 x 8in). This has been embroidered using the waste linen method described on page 43. The change of scale in the patterns is achieved by stitching the same motifs over a different number of threads of the evenweave fabric.*
The **Needlecase, Pinwheel** *and* **Paperweight Decoration** *are by Elizabeth Littlefair.*

Design

The starting point is choosing *what* you are going to embroider. Inspiration can be found in many places and a few of them are suggested in this chapter. Many subjects are suitable for blackwork, from geometric patterns to representational pictures of landscapes, buildings and figures, but it is often useful to think of blackwork as being planned from shapes, not lines. Except when used for borders on clothes or household articles, it is rarely a linear form of decoration. The shapes are not simply outlines that have to be filled in, but can be areas where the filling makes the shape.

Do not put a very small motif right in the middle of a large space. Let it fill the frame, overlap other shapes, touch the sides, or even spill over if you

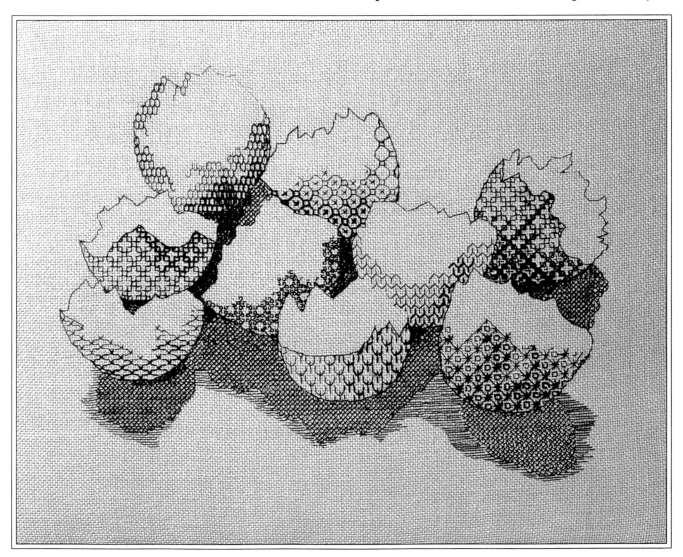

Broken Eggs, *by Joyce Bradshaw. Original size: 20 x 25cm (8 x 10in). By kind permission of Mrs Karen Lord. This striking design highlights the importance of blank areas (the insides of the shells), which contrast well with the densely stitched shadows and the tonal variations within each pattern.*

wish. In this way, more exciting shapes are made between the subject and the sides of the picture. Look carefully at the sizes and shapes of the areas. Some can be quite large, others quite small – but be careful, as too many different shapes can lead to a confusing piece of work. Always try to achieve a balance in your design.

Dark areas should not be too large or too concentrated, and you will find that they usually look best at the bottom of a design. The point of interest is generally more attractive if placed slightly off-centre.

If you can draw, the designing stage will be easier for you. Drawings done in charcoal, crayon or pastel are ideal for blackwork. If you use the side of a piece of charcoal, a drawing will not have a hard outline. This will encourage you to think in terms of areas of tone and not just of outlines. Detailed shading is too complicated to work out, and although an infinite variety of tones can be achieved when stitching, three to five are usually enough at the planning stage.

Spend a lot of time preparing a design; it is always worth while. Experimenting with ideas on paper using ink or paint not only saves wasting more expensive materials, but will also result in better-balanced designs. Your experiments may suggest new possibilities, so do not hurry this stage.

Trees, *by Adrie Philips. Original size: 18 x 23cm (7 x 9in).*
Thick and thin threads in both blackwork and darning patterns give form to this group of trees.

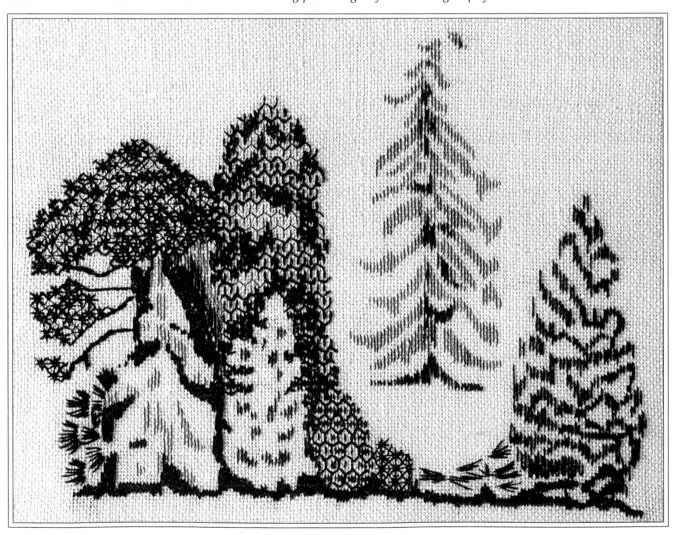

8

Sources of inspiration

Plants

These are a wonderful source of ideas. The overall shapes and variations within a line of trees can provide inspiration for embroideries, as can a group of shrubs in a garden, or detailed studies of individual plants.

Some plant forms, such as leaves, can be used directly. You can make a print by covering one side of a leaf with white paint and then pressing it down on to a dark-coloured paper. The veins and stems of the leaf can then be added in black ink. As well as prints, rubbings can be taken from any textured surface such as bark or wood-grain, and these too can provide ideas for stitch patterns.

See page 34 for some more ideas on designing tree forms.

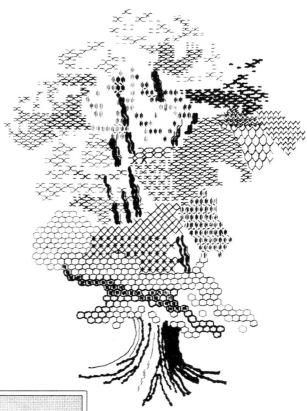

Tree, *by Beryl Jones. This was worked on linen using hexagonal, cross and zig-zag stitches. The step-stitch network is very dense on the right and well thinned at the top. A thick thread was couched for the trunk.*

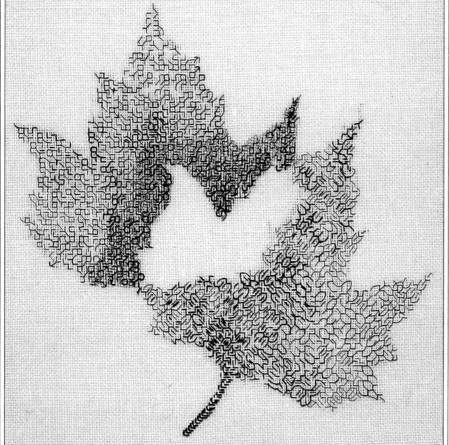

Leaves, *by Margaret Pascoe. By kind permission of Mr Jim Pascoe. Original size: 23 x 23cm (9 x 9in). Inspired by spraying over maple leaves.*

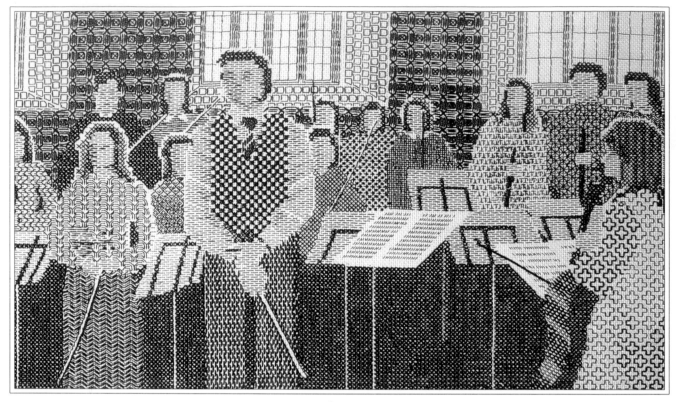

Godalming Youth Orchestra, *by Sonia Head. Original size: 21.5 x 37cm (8½ x 14½in).*
A good example of a design inspired by a black-and-white photograph.

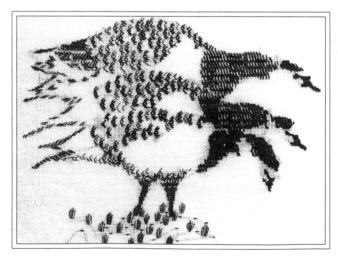

Three Geese, *by Margaret Pascoe. This was adapted from a newspaper photograph and was worked on linen using coton à broder, fil à dentelles and buttonhole silk, with added beads. Step stitch was used on the necks, and Vs and Ws on the bodies.*

Photographs and postcards

These are very useful, especially if already in black and white. It is helpful to obtain a black and white photocopy of a coloured photograph or card. This immediately shows the areas of different tones which many people find difficult to assess from a coloured picture.

Human and animal figures

Pictures of costumed figures such as the Elizabethan lady on page 11 are always popular, as there is scope for filling in the different areas of a historical costume with a wide variety of decorative patterns. It also reflects the craft's historical roots.

Children's books, particularly colouring books, often have simple illustrations which can be traced,

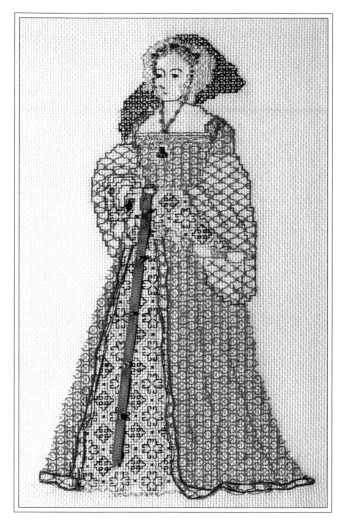

Jane Seymour, by Joyce Palmer.
Original size: 19 x 11cm (7¹/₂ x 4¹/₂in)
Beads, ribbon and the use of red threads add interest to
this interpretation of a design originally published in
Mary Hickmott's New Stitches magazine.

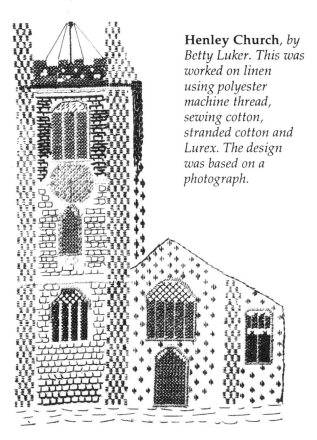

Detail of Minarets, an original design by Joyce
Palmer, in which traditional blackwork patterns are
stitched using various metallic threads and beads.

Henley Church, *by*
Betty Luker. This was
worked on linen
using polyester
machine thread,
sewing cotton,
stranded cotton and
Lurex. The design
was based on a
photograph.

enlarged or reduced and used in a design, while brass rubbings are an excellent source for formal figures such as mediaeval knights and their ladies.

Buildings

These are an ever-popular blackwork subject, as a lot of interest can be created in the textures of roofs, stonework, windows, etc. Photographs, sketches and even architectural plans can all easily be adapted for use in a pattern.

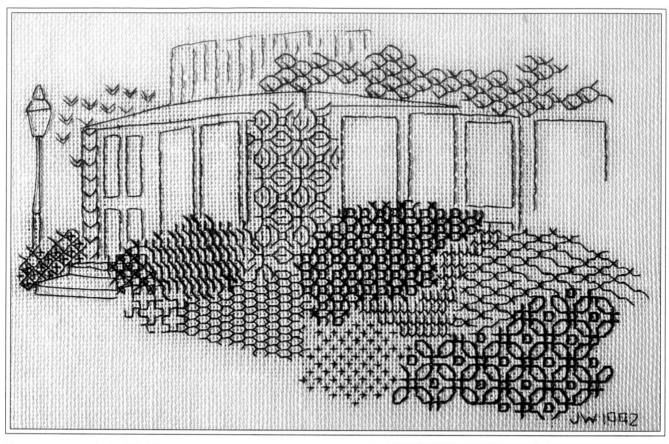

Conservatory, *by Judith Wharton.*
Original size: 11 x 18cm (4½ x 7in).
A variety of plant forms are suggested by patterns
which differ both in scale and density.

Maps and plans

These have many varied shapes for use in patterns, and can also provide lettering and symbols. Garden plans can be particularly attractive.

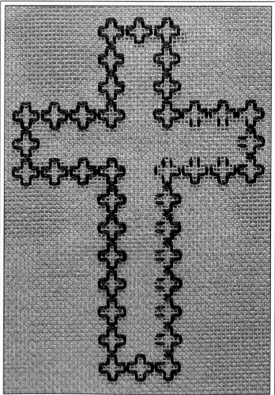

The shape of a cross made up of cross-shaped motifs on gold-sprayed canvas. The pattern has been only half stitched on one side, giving the impression of a plan of a church.
By Lesley Barnett.
Original size: 15 x 10cm (6 x 4in).

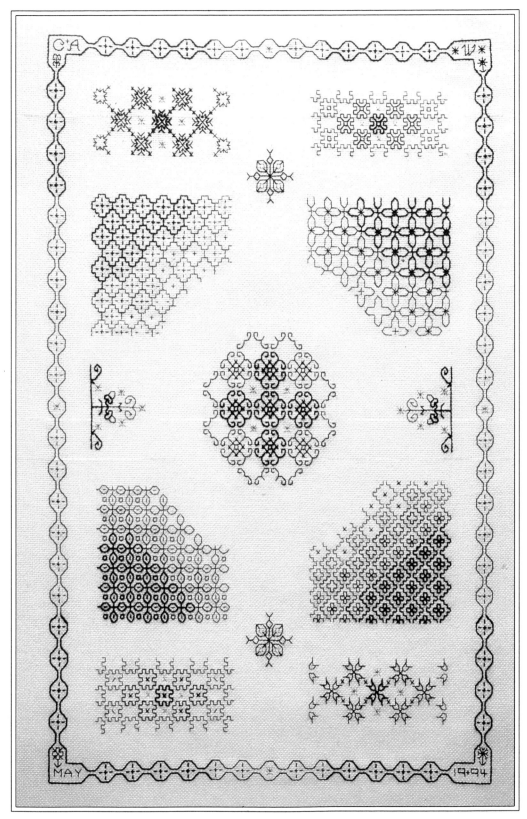

Knot Garden, *by Christine White. Original size: 40 x 27cm (15½ x 10½in).*
A garden plan has been used as a sampler to show different patterns and weights of thread.

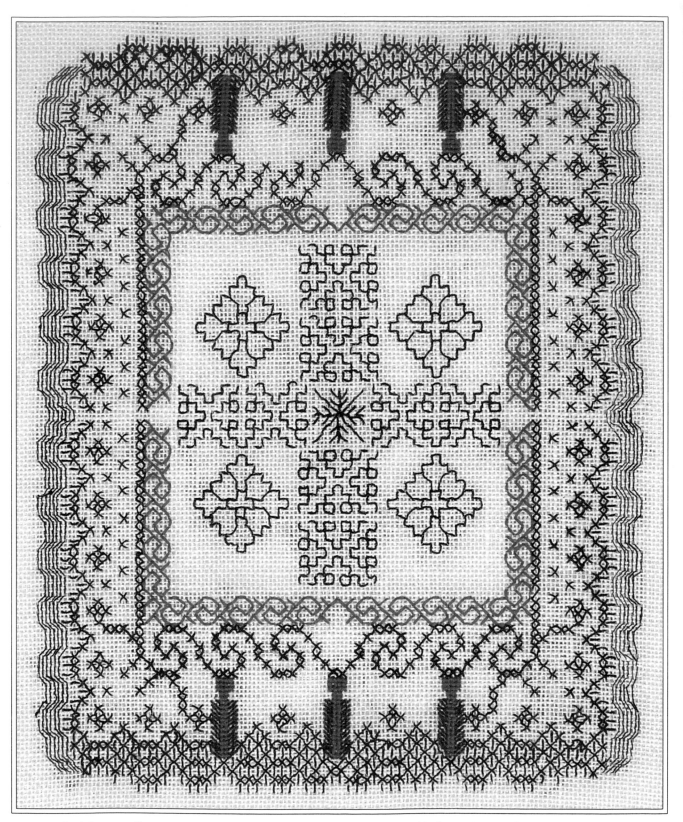

Tassels, *by Margaret Pascoe. Original size: 27 x 24cm (10¹/₂ x 9¹/₂in). By kind permission of Mr Jim Pascoe. Blackwork on canvas imitating black lace. Inspired by pieces of Berlinwork from the Embroiderers' Guild collection.*

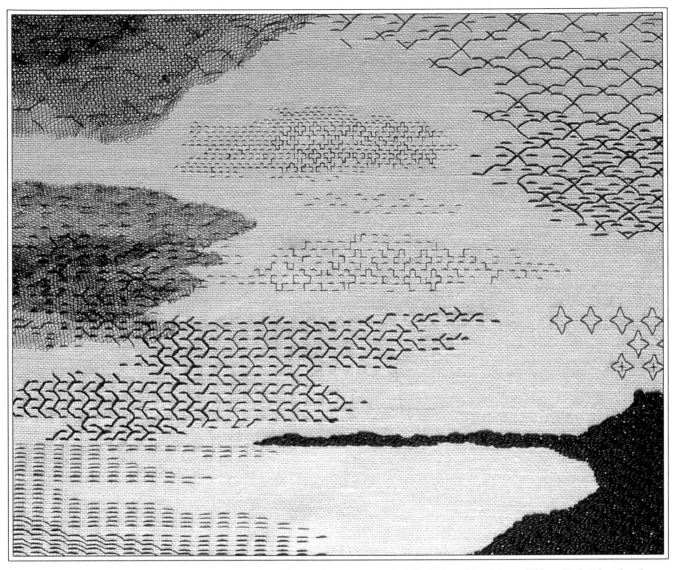

Coastal Clouds, by Lesley Barnett. Original size: 19 x 23cm (7½ x 9in). The clouds are depicted by layers of chiffon and broken patterns in different scales. Satin stitch is used for the strongly contrasting silhouette of the land and running stitch for the calm sea.

Contrast

There should be some very black areas (these could even be applied pieces of felt, kid leather or velvet if necessary), and some very light areas. For light areas, make use of the background material, and leave some areas free of stitching altogether.

Adapting work for embroidery

When doing a design for a specific article, the shape and size of it will influence the design. The number of threads per centimetre/inch will deter-

mine the size of the stitches, so it follows that the smaller the article, the finer the fabric, and vice versa. Do not attempt a very large piece of work as your first project. Unless you use a coarse fabric and thick threads, a large area will take a long time to fill and you may become discouraged!

In blackwork, as in any counted-thread embroidery, it is very frustrating if the pattern does not get going. So although areas can be one stitch wide, it is generally better to plan for at least four stitches at the narrowest parts of a design.

15

Some practice samplers can be made into such items as pincushions, bookmarks, buttons and belts, and because they are often worked on hard-wearing and washable fabrics, blackwork designs are particularly suitable for table linen.

Tracing designs

Use a piece of tracing or greaseproof paper to trace the outline of your design from your chosen photograph, drawing or print. It is not necessary to draw in the fine details at this stage.

Enlarging or reducing a design

The easiest way to enlarge or reduce designs to the required size is to use a photocopier. A black and white photocopy will give tonal variations and you can then use a simplified tracing to transfer the design to the fabric.

Alternatively, try the following method.

1. Draw a frame as close as possible to the edge of your traced design.

2. Divide the drawing into a number of equal-sized squares.

3. Decide how much larger or smaller than the tracing the finished design will be, then multiply or divide the dimensions accordingly. If each side is doubled in size, the total area will be four times as large as the original. In the example below, the original picture measures 5cm x 5cm (2 x 2in) and needs to be enlarged to 7.5 x 7.5cm (3 x 3in). Remember, both sides of squares and rectangles must always be increased or reduced in proportion.

4. Draw the new frame to the required size and divide it into exactly the same number of equal-sized squares as the original frame.

5. Copy the design into the corresponding squares as shown in the diagram below.

Marking light and dark areas on the design

After tracing and scaling the design to the required size, shade it in to indicate blackwork patterns of varying densities by using one of the following methods.

Using newsprint

Cut out dark, medium and light areas of tone from newsprint or newspaper photographs. These should be cut in the shapes of the design and glued on to the drawing. It is much easier to achieve the

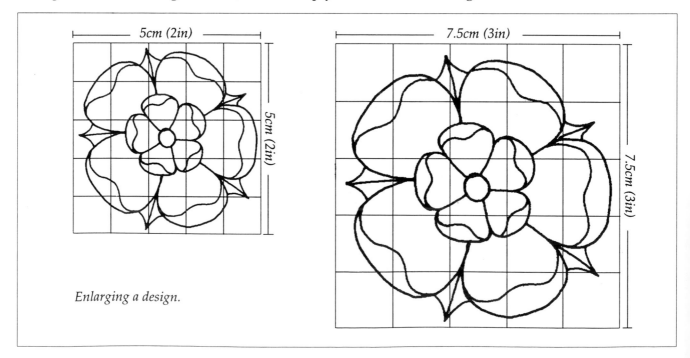

Enlarging a design.

5cm (2in) 5cm (2in) 7.5cm (3in) 7.5cm (3in)

right balance between light and dark at this stage, rather than when stitching on the fabric.

Tissue-paper collage

White tissue paper can be used on black sugar paper to indicate tone. Overlapping areas of tissue once or twice will indicate varying mid-tones and white poster paint can be applied to indicate the very lightest tones.

The areas should be kept to a few simple shapes. The edges may be rounded or angular, but too many indentations are not practical to work and should be avoided. If you find that cutting out is difficult because of an awkward or a very small shape, the area is probably unsuitable. To overcome this, several adjacent small areas can all be merged into one. Shading can also be done with a crayon or soft pencil to indicate changes of tone.

The finished design showing dark and light areas can now be used as a working drawing. Trace the outline of the design on to tissue paper and transfer it to the fabric.

Transferring designs to the fabric

1. Cut the fabric along a line of weave, allowing an edge of at least 5–7.5cm (2–3in) around the design. To prevent wastage due to fraying, neaten the raw edges of fabric as soon as possible after cutting, and then iron the fabric.

2. Trace the design on to ironed tissue paper or greaseproof paper (tracing paper is generally too firm to use). Mark the horizontal and vertical planes of the design at its centre (a–c and b–d).

3. Tack the same lines along the warp and weft at the centre of the fabric (A–C and B–D).

4. Pin the tissue paper to the fabric, matching the centre horizontals and verticals, and keeping the work as flat as possible.

5. Tack along all the lines of the design with small running stitches in sewing thread, using the same colour as you intend to use for your embroidery. Threads of any other colour may show in the finished work, as it is not always possible to remove every trace of a thread.

6. Gently tear off the tissue paper. Use the point of a needle to score the paper along the tacking lines. The paper will then be easier to tear away without pulling the tacked design out of place.

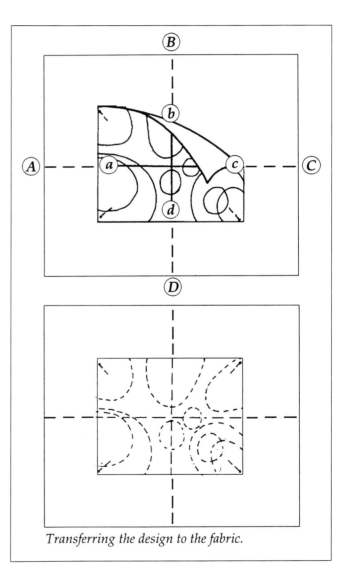

Transferring the design to the fabric.

17

Materials and equipment

This craft does not need an immense amount of equipment – really just evenweave fabric, needles and threads – and you may well already have all the necessary requirements in your sewing basket.

Fabrics

Background fabrics

Choose a fabric on which the warp and weft are clearly visible and on which the threads can be counted easily. Make sure that the fabric threads per centimetre/inch are in the right scale for your design. Weaves vary from about 4 to 12 threads to the centimetre (10 to 30 threads to the inch). Fabrics that are finer than 12 threads to the centimetre (30 threads to the inch) are hard on the eyes, as their threads are difficult to count. So do not choose a very fine fabric for your first project.

The number of threads per centimetre/inch should be equal for both warp and weft. There are many evenweave furnishing and dress-making materials which give good results and are less expensive than the traditional linens. Suggested background fabrics to use are (graded from coarse to fine): hessian; woollen and synthetic hopsacks; finer woollens and tweeds; evenweave linens; linen-like rayons; polyesters and cottons; Aida (block-weave); Hardanger fabric (double-weave).

Applied fabrics

Chiffons and nets can be used on their own for very light areas, held in place with tiny stitches over the individual threads of the net, which can be of either square or hexagonal mesh. If it is coarse enough it can be added to the background and then embroidered, but this requires great concentration.

Felt, suede, leather and plastics can be applied to the darkest areas. You can also pad applied fabrics with layers of felt.

Painted fabric backgrounds

For contemporary blackwork, fabric paints, inks or even car spray paint can be used for some areas in a design. Sponging, air-brushing, spattering with a toothbrush or spraying through a stencil can form a useful contrast to stitched areas. Printing with simple blocks or items such as leaves can be used for repeat designs.

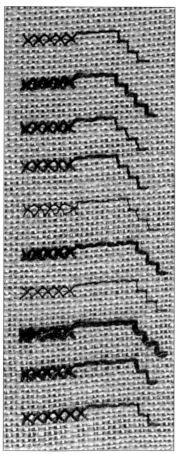

Choose a fabric on which the warp and weft are clearly visible and on which the threads can easily be counted.

__Falling Leaves__, by Lesley Barnett. Original size: 23 x 18cm (9 x 7in). The background fabric has been sprayed with gold paint over three leaves which have then been used to print the other half of the design.

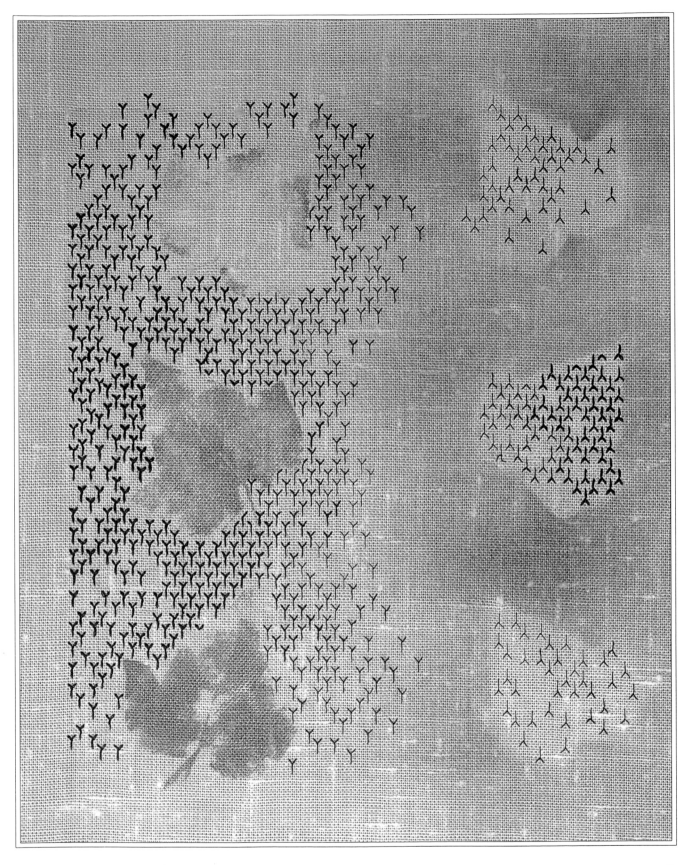

Threads

Choose a thread that will not distort the fabric by being too thick. When necessary, use a thicker thread, rather than more lengths of a stranded cotton, as these will become fluffy and have a tendency to pull unevenly, leaving little loops at each stitch. Machine-embroidery threads, silk or synthetic sewing thread all give a crisp, clean look.

Some useful threads are: machine embroidery No. 50; silk buttonhole twist; coton à broder; coton perlé; and soft embroidery cotton.

Any sewing cotton, synthetic or silk thread can be used in place of machine-embroidery thread, and thicker cottons, Nos. 10, 20, 24 and 36, are useful too. Fine lace threads, such as fil à dentelles, are beautifully smooth, and crochet cottons Nos.

20 and 40 produce a very neat finish. Black coton à broder is available in a range of thicknesses from No. 12 to No. 25, which are all useful.

Fine crewel wools or darning wools and Danish flower threads are useful instead of coton à broder. Perlé threads Nos. 5, 8 and 12 give a soft sheen.

Soft embroidery cotton is the thickest thread that can be used on fabrics from about 5 threads to the centimetre (12 threads to the inch). Knitting yarns, tapestry wools and fine ribbons and cords can be couched on to the background or used to stitch with on coarse fabrics.

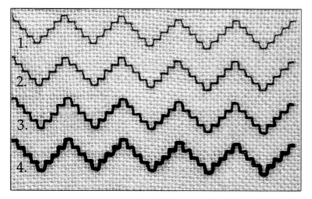

1. Sewing cotton.
2. No. 12 cotton perlé.
3. No. 8 cotton perlé.
4. No. 5 cotton perlé.

Beads

Beads, bugles or sequins may also be used, but they should be considered when you are planning the design and not just used as an afterthought.

Needles

Choose a needle which will slip easily between the fabric threads. A blunt-ended tapestry needle is much less likely to split either fabric or stitching threads than a sharp-pointed one. The size of the needle is important – too large and it can distort the fabric and waste time while being rethreaded. Too small a needle will wear out the thread. Sizes between 18 and 26 are probably the best.

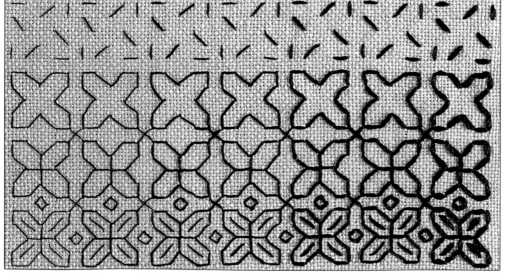

This sample by Lesley Barnett shows how the same pattern can be made lighter or darker by varying the thread used and by the subtraction or addition of stitches within the pattern. Original size: 7.5 x 13cm (3 x 5in).

Preparing to work

Frame your fabric, preferably on a rectangular frame, and leave as much space as possible around the design. The simplest way to do this is to stretch the fabric on a wooden picture frame and pin it with drawing pins or staples. Round 'tambour' frames (where the fabric is held between two rings) can be used, but they tend to leave a mark on the edge of the fabric.

Sit with a good light above or slightly behind you, and be sure to have a plain background behind your work frame. The holes between the threads of light-coloured fabrics show up better with a dark background behind the frame. Conversely, if you are working in light threads on a dark or coloured fabric, a light background will show the holes more clearly.

Rest your work frame on the edge of a table and adjust it to a comfortable working height.

Use a small piece of fabric on which to try out stitches first, as unpicking mistakes not only causes frustration but will also leave grey marks on the fabric. Use a medium thread when trying out a stitch. If you have to unpick stitches, some black fluff from the sewing thread is often left behind. This can be removed by dabbing the area, front and back, with the sticky side of a small piece of masking tape (not cellulose tape). This will remove the tiny pieces of fluff without leaving any sticky residue on your work.

Sewing method

Use a two-handed technique to get the most even stitching. Stab-stitch with one hand (usually the less able hand), and pull down, or push up the needle from behind, with the more able hand. Always try to go down with the needle where a hole is already occupied by a stitch, and come up where there is an empty hole in the fabric. This will prevent pulling and distorting the existing stitch.

Start each new length of thread with a knot in one end. Take the needle through from the front of the work about 2.5 or 4cm (1–1½in) ahead of the first stitch. As you make the first few stitches, ensure that they cover this starting thread on the back. Once this thread is secure, you can cut the knot off. As each length of thread is finished, it should be woven into the back of the stitches.

Do not pass threads over empty spaces at the back of your work as these threads will be visible from the front through the holes in the fabric.

Do not pull each stitch too tight, unless a 'pulled' fabric effect is required. Be careful to get the pull in the right direction, as different diagonal stitches make varying angles, depending on where the next stitch begins and ends. Some threads, particularly buttonhole silk, will not pull as well as others.

When covering an area of fabric with an even 'net' of stitches, try to get a rhythm and pattern in the way the stitches are worked and an evenness in the way they are pulled. This will not only make the back neater, but will also give a smooth, clean look to the work.

When working close to the edge of an area where a complete pattern is required, always go over the edge rather than stop inside it if you are in any doubt about where to finish.

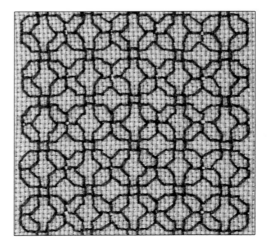

When covering an area with an even net of stitches, get a rhythm and pattern in the way the stitches are worked and an evenness in the way they are pulled for a neat effect. (Sample by Elizabeth Littlefair.)

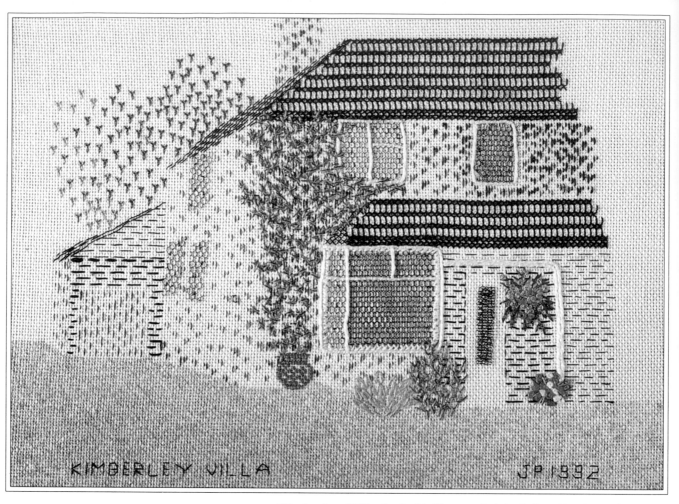

Kimberley Villa, *by Jackie Pearce. Original size: 18 x 23cm (7 x 9in).*
Touches of coloured free embroidery enliven this lightly textured design.

Colour in blackwork

Some historical pieces of blackwork were embroidered in red thread on different natural linens. If you find blackwork too sombre, then try working with coloured threads. It is best to aim for a strong contrast between fabric and thread. Blackwork embroidery relies on tonal contrast for its effect even where colour is used.

It is possible to introduce two or more colours when using blackwork stitches, and if two patterns are allowed to overlap, a third colour may be produced. Some embroiderers use a number of naturalistic colours to build up an area of a picture composed of blackwork stitches, but to be effective, care is needed with the tonal values of the colours used.

In the past, a fine gold thread was sometimes used. This can be very effective to highlight your work if used with discretion (see pages 23, 24 and 28).

Thirteen Squares, *by Basil Swindells.*
Original size: 21.5 x 30cm (8½ x 12in).
This colourful mathematical design is stitched on Hardanger fabric using cotton flower threads.

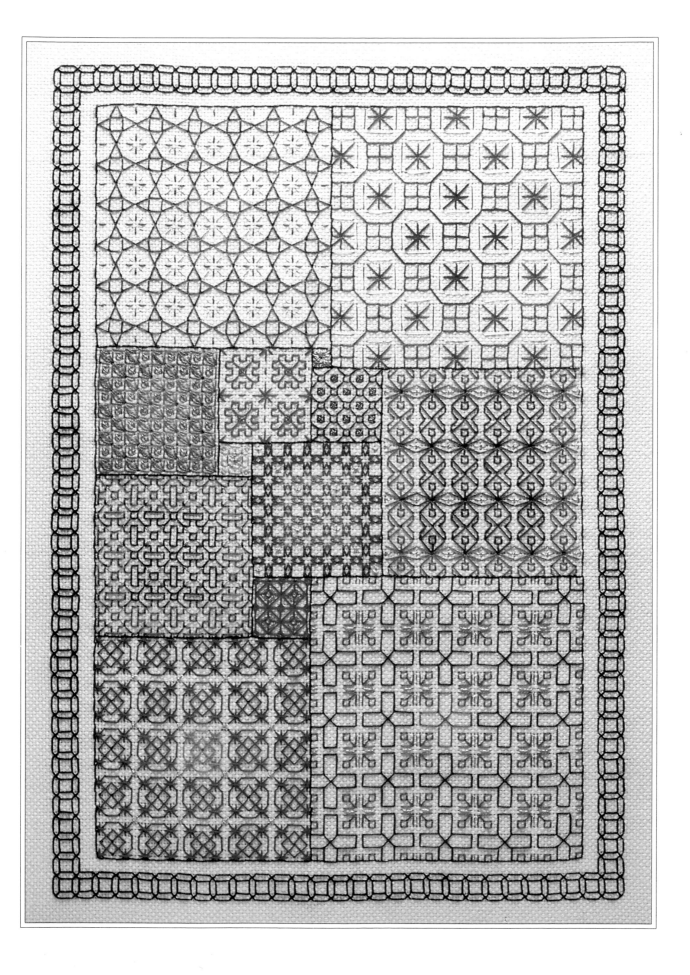

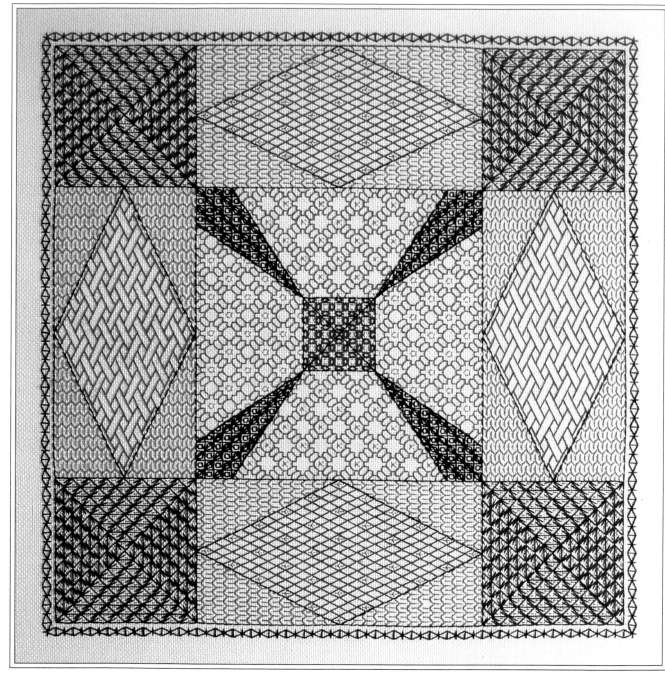

Parquet Floor, *by Basil Swindells.*
Original size: 33 x 33cm (13 x 13in).
This subtle coloured design shows different tone values achieved by
careful choice of both pattern and thread. Inspired by a parquet floor at
Ham House, a property belonging to the National Trust.

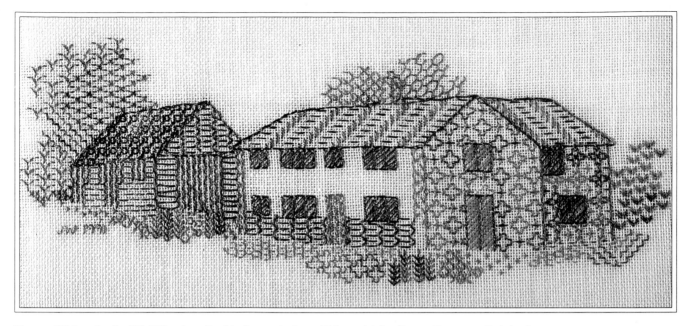

Pen-y-Rhiw, *by Judith Wharton. By kind permission of Mr and Mrs Bruce Grenyer. Original size: 13 x 24cm (5 x 9½in). Natural colours are used both in formal patterns for the buildings and in broken patterns for the plant forms.*

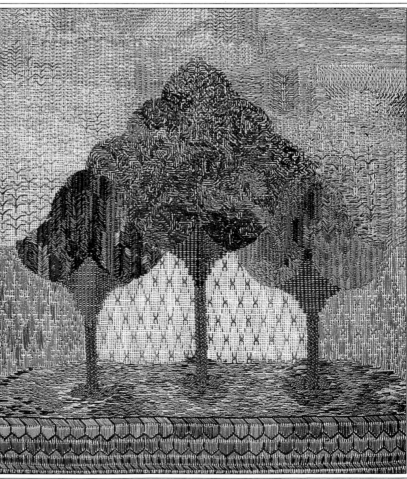

Three Trees, *by Margaret Pascoe. By kind permission of Mrs Barbara Richardson. Original size: 32 x 29cm (12½ x 11½ in). A semi-abstract design using blackwork patterns and free surface stitchery.*

Stitches

Blackwork stitches are basically all variations of double running (Holbein) stitch. Nearly all stitches can be worked horizontally, vertically or diagonally.

When working on fabric stretched on a frame, it is wrong to make a stitch with only one hand movement. Although each stitch is shown being worked like this in the following diagrams, each one should be made with two definite hand movements, as described on page 21.

The stitches are all shown over two threads of the fabric. If tiny stitches are made over only one woven thread they may disappear into the weave and so leave a gap in the pattern. You may be able to avoid this if you take great care with the stitching technique.

Stitches may also be made over three or four fabric threads in order to vary the scale of a pattern.

When stitching over block-weave fabrics, such as Aida, each stitch is normally taken over one block of the weave.

Double running stitch

The first line of stitches moves from right to left, over two threads of the fabric and under two threads of the fabric. The second line goes from left to right and fills in the empty spaces. Notice that these stitches are placed diagonally. This gives a smoother line than the horizontal stitches shown in the third line.

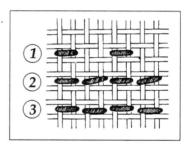

Straight stitch

This is a single stitch that can be worked at any angle.

These stitches are stitched over two threads of the fabric. Interest is created by choosing the embroidery threads to pick up the subtle colours of the tweedy, mottled fabric.

Back stitch

This is an alternative to double running stitch. The needle comes out at the right-hand side at a, and then, passing backwards over two threads in the fabric, goes in at b and emerges at c. It goes into the front of the fabric at a and then passes across the back to come out at d, two holes ahead of the second stitch.

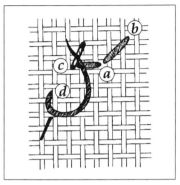

Back-stitch squares

1. With the thread emerging at d, make a stitch by passing over two threads upwards and enter the needle at a. It then passes diagonally at the back and emerges at b.

2. The needle goes in at d and then passes diagonally to c at the back.

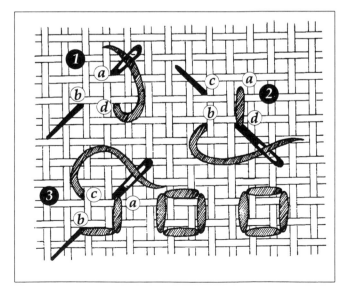

3. The thread then passes from c to a on the front of the fabric and diagonally to b on the back.

4. The square is completed by making a stitch from b to c. The diagram also shows two completed squares separated from each other by two threads.

Ringed back stitch

1. Working from right to left across the fabric, come up with the needle at the arrow, go down at a, up at b, and so on. Finish on the same horizontal strand of the fabric as you started on.

2. Make a similar wavy line of stitches from left to right, completing each ring with the three stitches needed.

3. The final diagram shows six completed rings and diamonds made by joining two lines of rings.

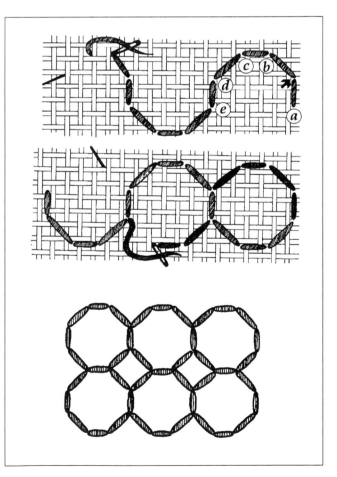

27

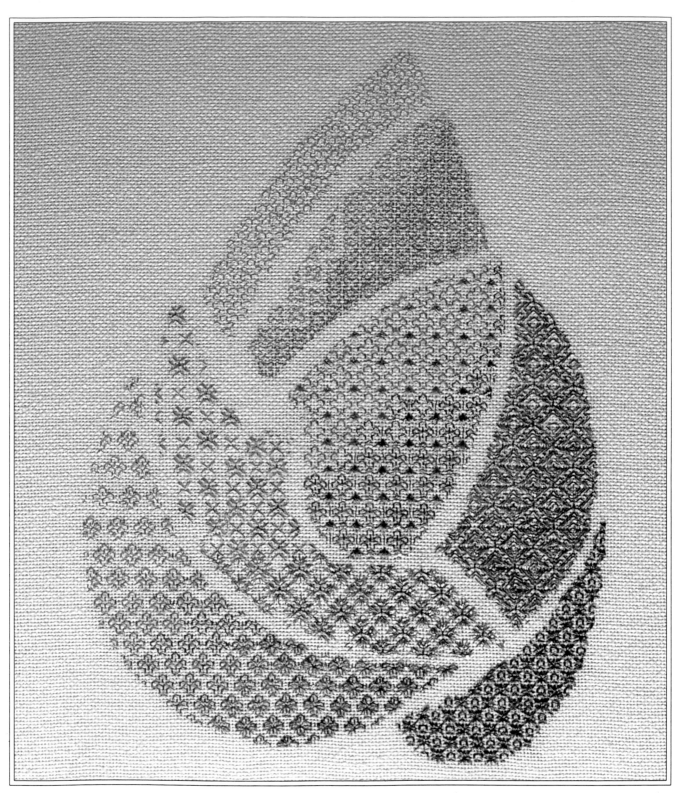

Pear, *by Joyce Bradshaw. By kind permission of Mrs Karen Lord. Original size: 23 x 19cm (9 x 7¹/₂in).*
The subtle shading is achieved by varying both the density of pattern and the shade of thread with each area,
some of which are highlighted with fine gold thread.

Patterns

Patterns are made up of units created with the basic stitches. Simple units can be combined to make a wide variety of patterns, some of which can be seen in the samples which follow.

Unless a disturbing effect is required, do not use too many patterns in the same piece of work. Several patterns which relate to each other will have more harmony than those patterns that have very different origins.

Choose a pattern that suits the shape and function of the area, and aim to give the right look to each shape. If this is done carefully, the pattern itself should be unobtrusive.

Each pattern has a character of its own. Some are heavy and solid and some light and mobile. For a delicate, fly-away shape at the top of a design, a heavy square pattern is obviously unsuitable. So be careful to balance your design before stitching.

If possible, begin your work on a medium tone near the centre of the design.

Some patterns are denser and more tightly stitched than others. These can be adjusted by enlarging, reducing, thickening, thinning or combining the stitches until you get the right 'weight'.

Areas do not always have to be filled in with the chosen pattern. Vary the threads, light and shade within an area.

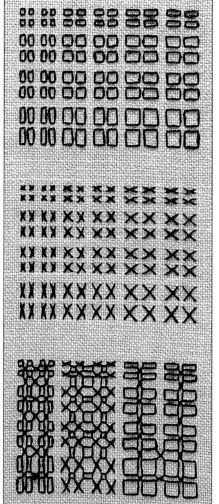

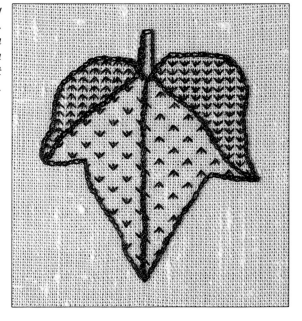

A small leaf design by Lesley Barnett. Original size: 7 x 6cm (3 x 2½in). One pattern used in two different densities.

Boxes and Crosses, *by Lesley Barnett. Original size: 13 x 5cm (5 by 2in). Changing scale and proportion in two basic units which are then combined to produce further patterns.*

To make patterns darker

1. Concentrate the stitch by using the same thread over fewer holes. Take care that lines do not disappear altogether when passing over a single thread.

2. Use a thicker thread over the same number of holes, but do not distort the fabric by pulling too hard.

3. Add extra lines of stitches to the pattern in the densest areas.

To make patterns lighter

1. Use a larger scale of stitches, *i.e.* the same threads over a larger number of holes.

2. Use a thinner thread over the same number of holes.

3. Omit parts of the pattern by leaving blank spaces within the areas.

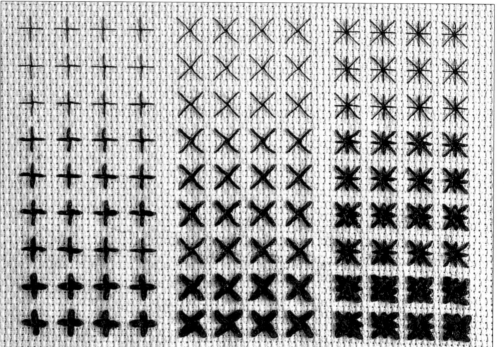

To make patterns darker, use a thicker thread over the same number of holes.

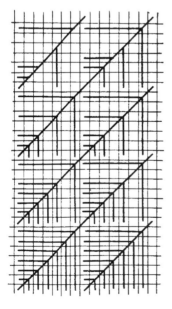

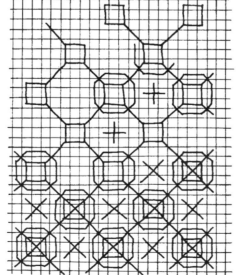

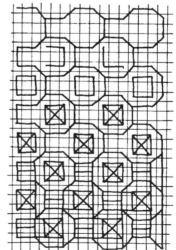

Three patterns showing varying density.

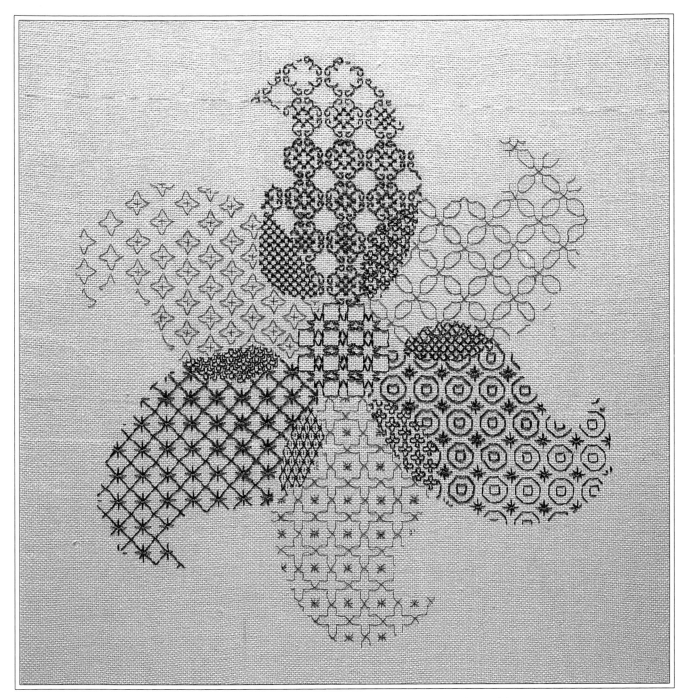

Green Sampler, *by Lesley Barnett. Original size: 28 x 28cm (11 x 11in). The traditional buta or paisley shape is here repeated to create a design in which thirteen different patterns are used. The weight of thread is varied within each of the large areas. The eye 'reads' the curved shapes although none of them is actually outlined.*

Step-stitch patterns

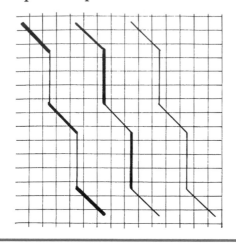

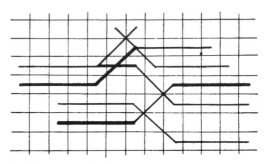

Random step stitch.

Step stitch — a combination of vertical and diagonal stitches.

Zig-zag patterns

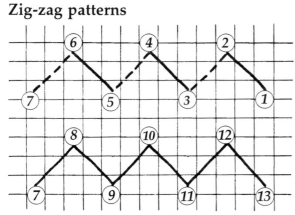

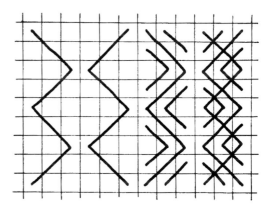

Zig-zag stitch. First journey from right to left. Then bring your needle up through the fabric on odd numbers and down through the fabric on even numbers. Second journey from left to right.

Zig-zag variations. Added threads increase the tonal value from left to right.

T-stitch patterns

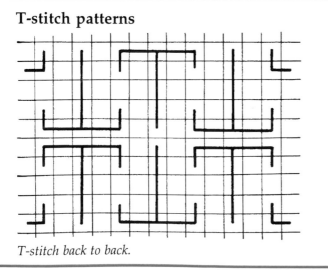

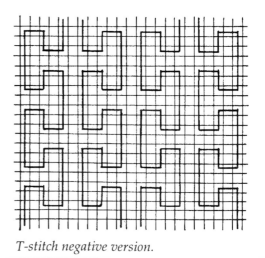

T-stitch back to back.

T-stitch negative version.

Tree-stitch patterns

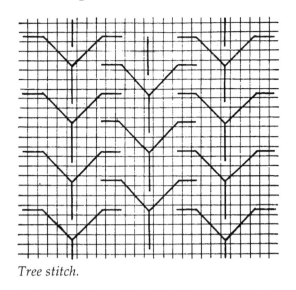

Tree stitch.

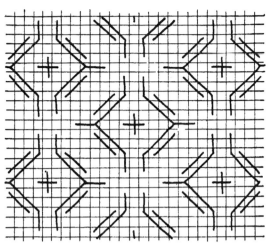

Tree-stitch pattern reversed and combined.

Hexagonal patterns

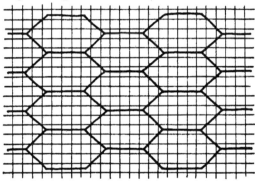

Long hexagons. The length of the stitch can be varied. If all the stitches are of equal length, a honeycomb network is produced.

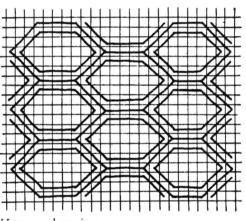

Hexagonal paving.

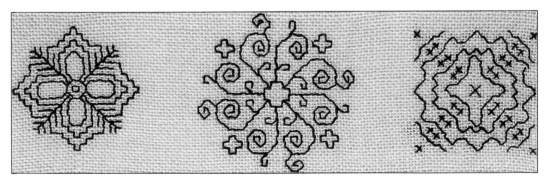

Three elegant blackwork motifs by Elizabeth Littlefair.

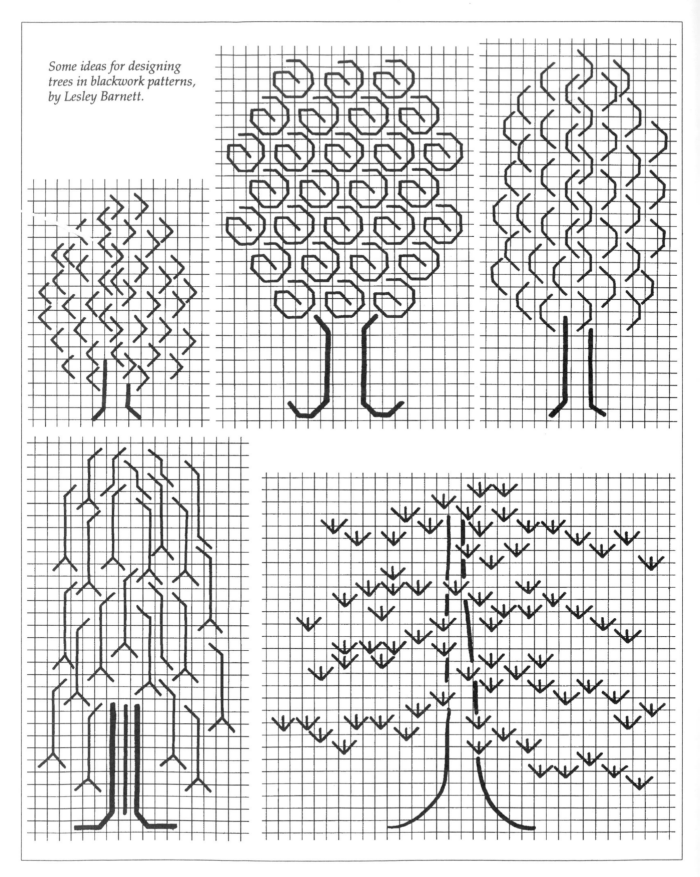

Some ideas for designing trees in blackwork patterns, by Lesley Barnett.

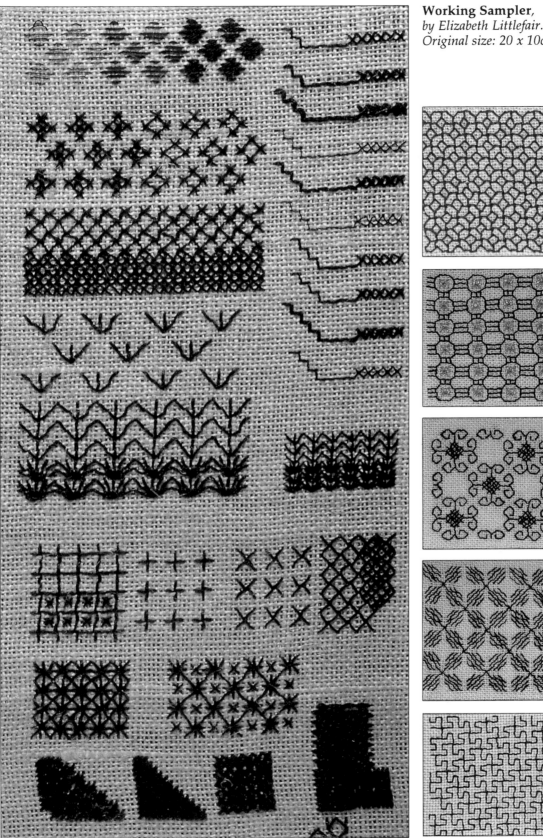

Working Sampler,
by Elizabeth Littlefair.
Original size: 20 x 10cm (8 x 4in).

Some useful blackwork filling patterns by Elizabeth Littlefair.

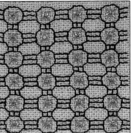

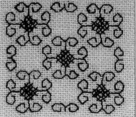

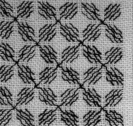

Borders and corners

You can make some beautiful borders by repeating and joining motifs, embroidering rows of alternating different patterns, etc.

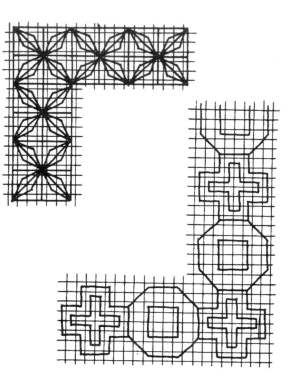

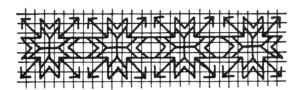

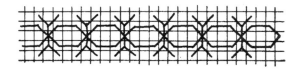

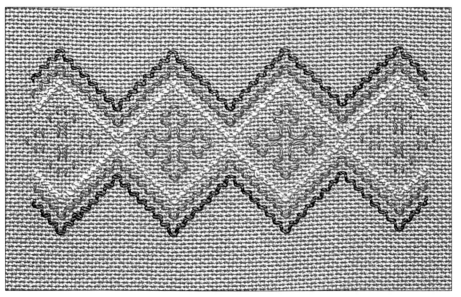

Two ideas for borders by Lesley Barnett.

A border with very little contrast.

The same border with rather more contrast.

The strong contrast of black thread on a white background.

A repeated wave motif makes a pleasing border.

A simple pattern highlighted with a touch of gold thread.

Introducing a small amount of colour to black.

Meeting in the middle and turning the corner.

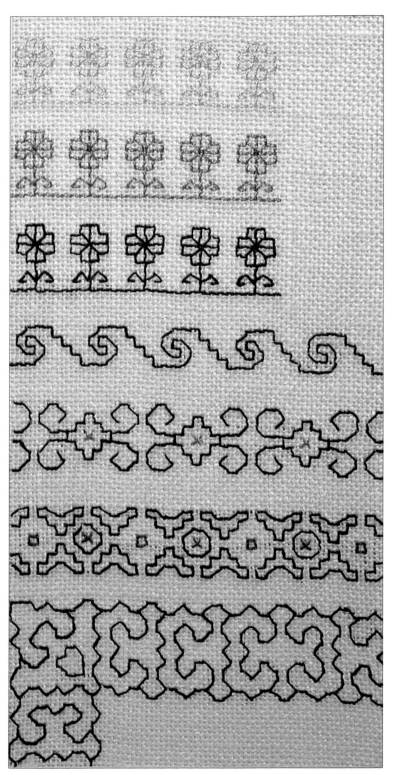

Some ideas for borders and corners by Elizabeth Littlefair.

Family Portraits, *by Patricia Sales.*
Original size: 60 x 74cm (24 x 29in).
This embroidery makes use of blackwork for
the 'photographs' set into a background of
appliqué and machine embroidery on hand-
made paper which is mounted on a sheet of
Perspex.

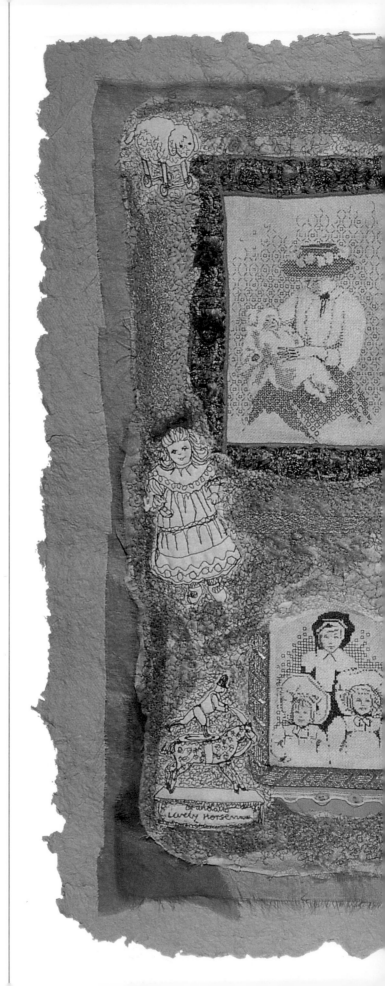

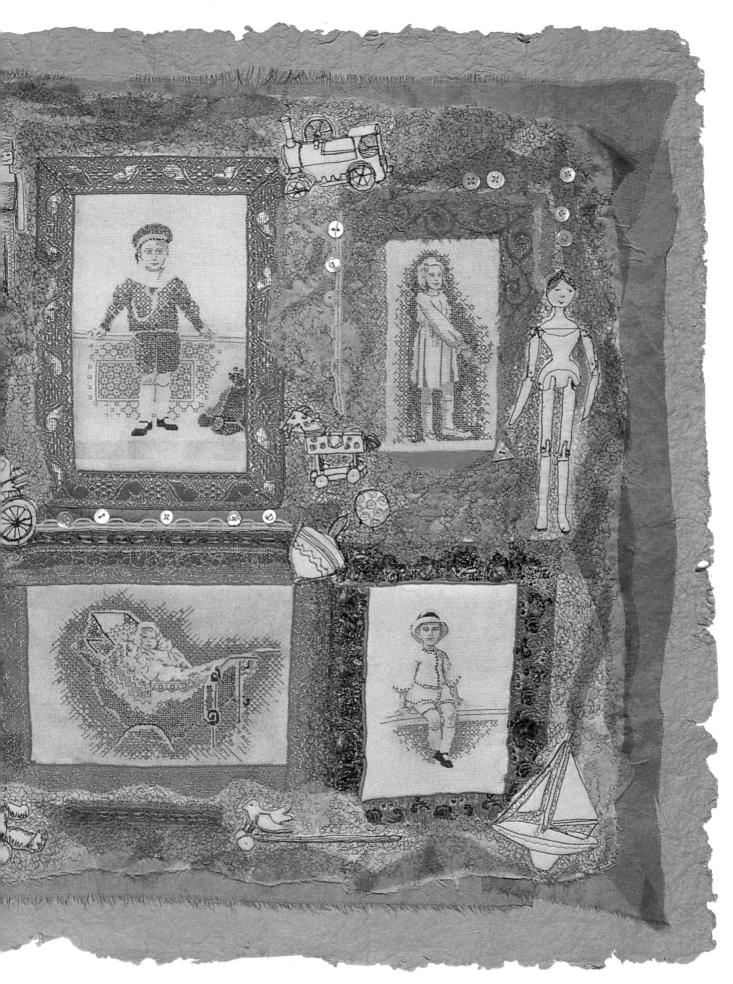

Two details of **Family Portraits**, *by Patricia Sales. These details show the use of subtle colours appropriate to old photographs. The broken pattern gives a soft edge to the background and contrasts with the fine dense patterns and the unstitched areas on the figures.*

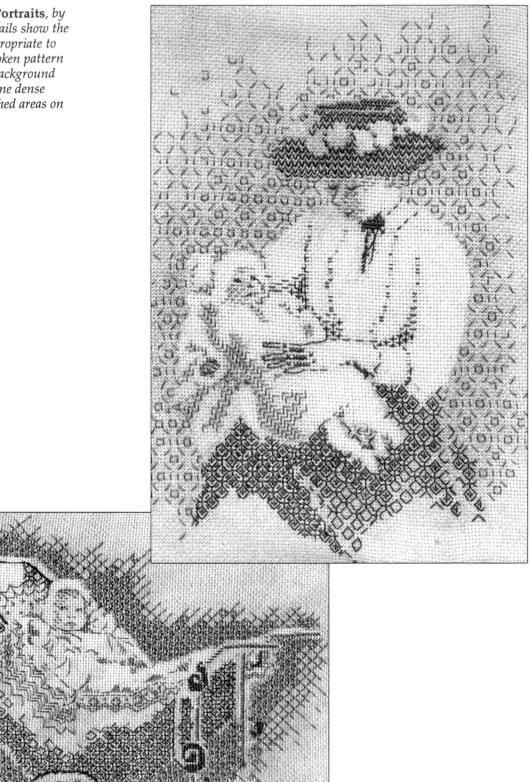

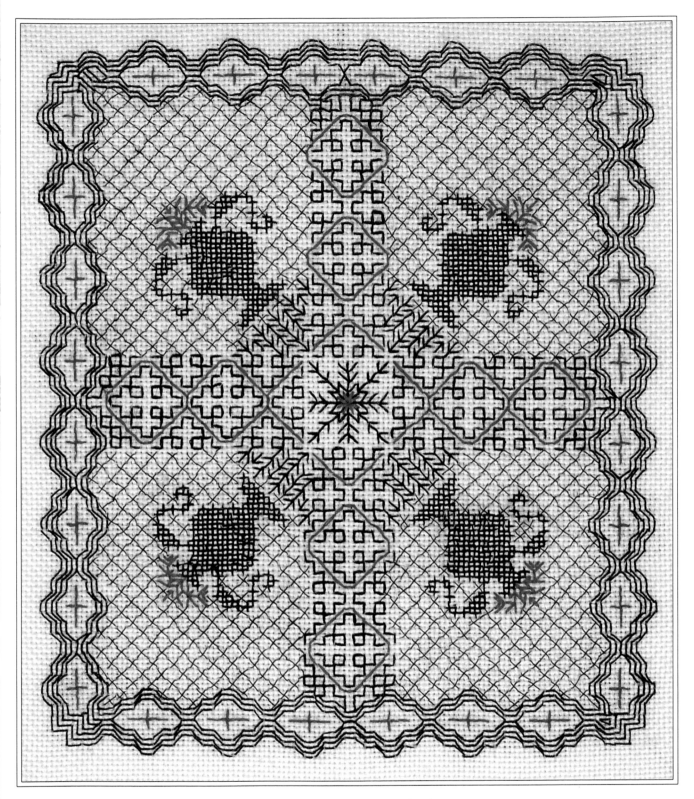

Urns, by Margaret Pascoe. Original size: 25 x 21.5cm (10 x 8½in). By kind permission of Mr Jim Pascoe.
Blackwork on canvas imitating black lace. Inspired by pieces of Berlinwork from the Embroiderers' Guild collection.

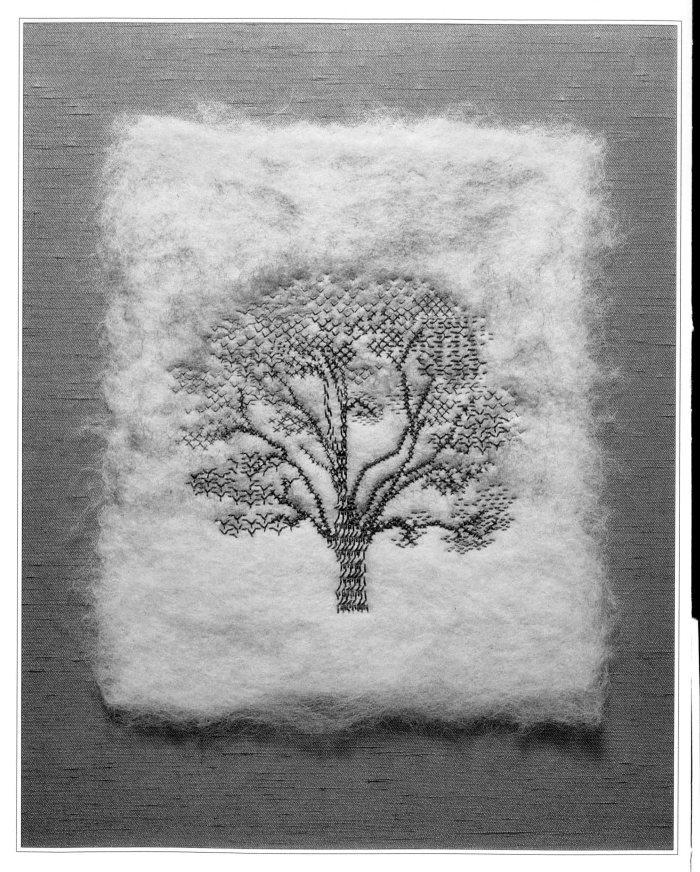

Blackwork on non-evenweave fabrics

It is possible to extend the use of the precise geometric patterns of blackwork to embroidery on fabrics where the weave cannot be counted. Closely woven fabrics such as silks and non-woven fabrics such as felt (manufactured or hand-made) contrast well with the detailed stitching of blackwork. Lay canvas or linen fabric on top of the chosen background material and carefully stitch the patterns through both layers. The canvas or linen threads are then withdrawn, leaving the evenly stitched patterns.

When using fine fabrics such as silk, it is advisable to back the work with a supporting fabric such as a fine soft cotton. The fabric must be held taut in a frame, as the stitch tension needs to be firm throughout so that the stitches lie correctly once the threads of the evenweave fabric have been withdrawn.

It is useful to try a small test piece using your chosen fabric and threads before beginning a large project.

Method

1. Mount the cotton backing fabric in a rectangular frame, then lay the silk fabric on this backing and the evenweave fabric on top of the silk, ensuring that the straight grain of all three fabrics is matched exactly.

2. Carefully tack together the three layers from the centre, both horizontally and vertically, at approximately 5cm (2in) intervals, keeping the three layers flat and straight as you tack.

3. All stitching should be started using the waste knot method described on page 21 and finished by carefully running the end of the thread through the back of the existing stitches.

4. Stitches must be made in two movements, keeping the needle vertical as it enters the fabric; avoid piercing the threads of the evenweave fabric by using a fine tapestry needle (size 26).

5. Tacking stitches may be removed as the work progresses if they interfere with the embroidery; otherwise you should remove them all when the work is completed.

6. Once all the embroidery is finished, remove the evenweave fabric thread by thread, leaving the embroidered design on the silk material. Start withdrawing the vertical threads one by one, using a tapestry needle to help separate each thread. Once all the vertical threads have been removed the horizontal threads will come away much more easily.

7. If any of the embroidery stitches have become loose, carefully adjust the tension by pulling individual stitches gently at the back.

Opposite
Oak Tree in Winter, *by Lesley Barnett.*
By kind permission of Miss Aileen Rickard.
Original size: 30 x 23cm (12 x 9in).
Embroidered on hand-made felt using the technique described on this page.

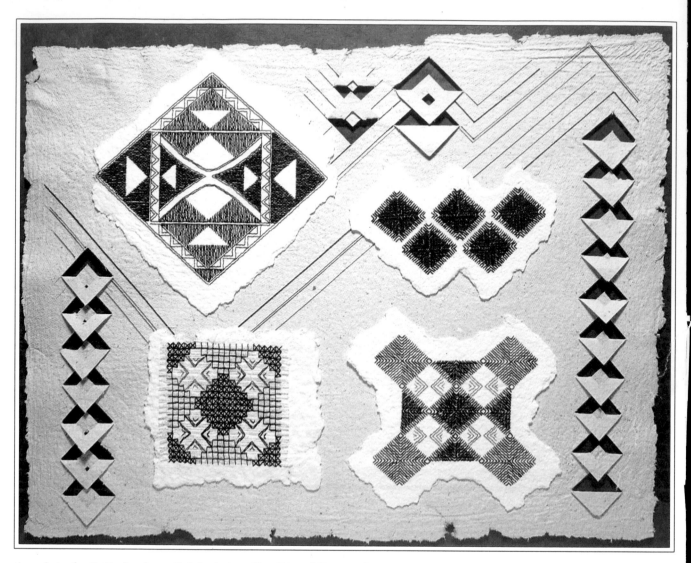

Amulets, *by Betty Lardner. Original size: 43 x 56cm (17 x 22in). Patterns based on African amulets. Stitched on hand-made paper using the technique described on page 43. Some of the linen threads have been left in place, adding texture to the embroidery.*

OPPOSITE
From Black to White, *by Lesley Barnett.*
Original size: 60 x 90cm (24 x 35in).
Twelve panels of handmade felt using a variety of natural fleece graded from black to white mounted on silk dupion. Embroidered with blackwork patterns using white, cream and black silk, linen and cotton threads and some gold threads.

44

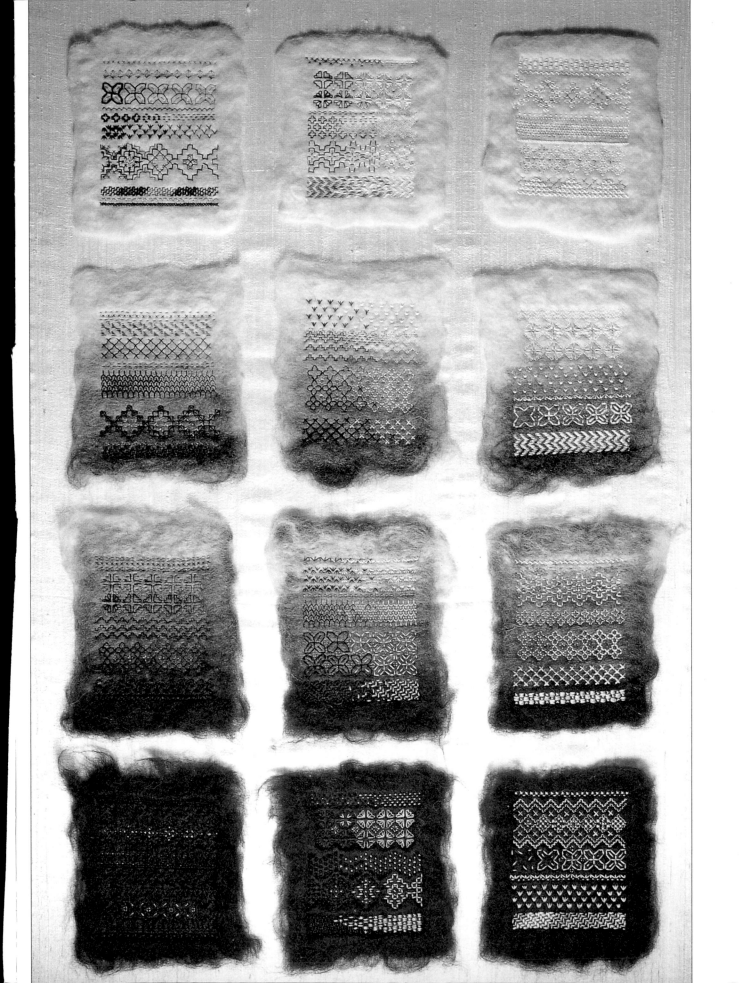

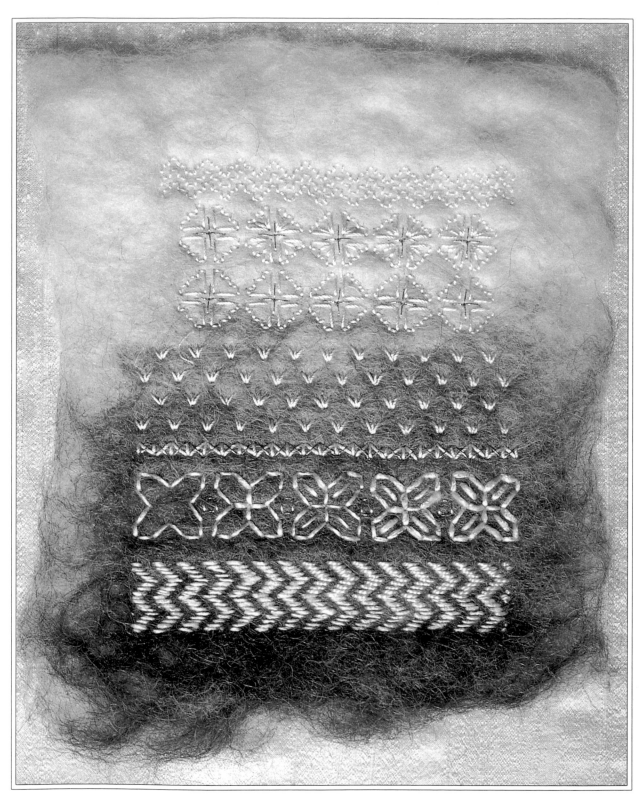

*Detail of **From Black to White**, by Lesley Barnett, showing blackwork patterns in white thread on a background graduated from black to white.*

Detail of **From Black to White,**
by Lesley Barnett.

Index

Suppliers

If you have any difficulty in obtaining any of the items mentioned in this book, write to the Publishers for a constantly updated free list of suppliers, including mail-order.

Search Press Limited, Wellwood, North Farm Road, Tunbridge Wells, Kent TN2 3DR.